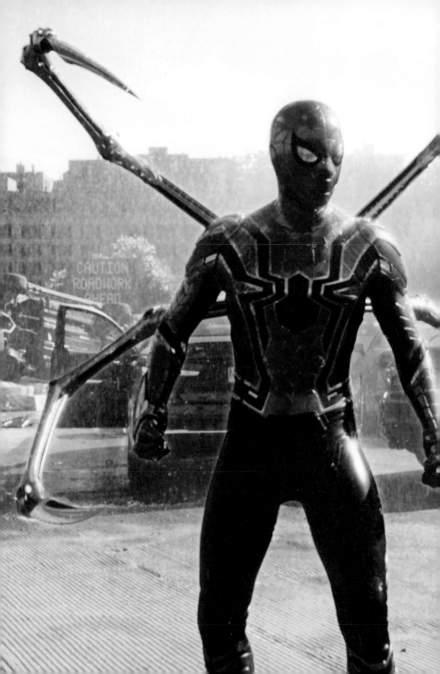

MARVEL STUDIOS

BE MORE SPIDER-MAN

WRITTEN BY KELLY KNOX

CONTENTS

CALL ON YOUR INNER HERO

Spider-Man's powers are not the most amazing thing about him. More amazing is the responsibility he feels for those around him as well as his ability to learn from failure and believe in himself. So if it ever feels like the world is against you, here's the good news: you don't have to be a Super Hero to rise to the challenge. You are amazing too. You can do whatever Spider-Man can. Trust your instincts and find your inner super strengths. Then you too can swing through life with good friends at your side.

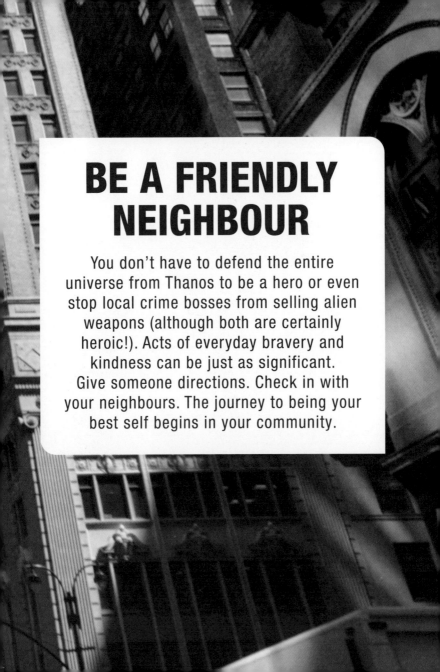

BE A FRIENDLY NEIGHBOUR

You don't have to defend the entire universe from Thanos to be a hero or even stop local crime bosses from selling alien weapons (although both are certainly heroic!). Acts of everyday bravery and kindness can be just as significant. Give someone directions. Check in with your neighbours. The journey to being your best self begins in your community.

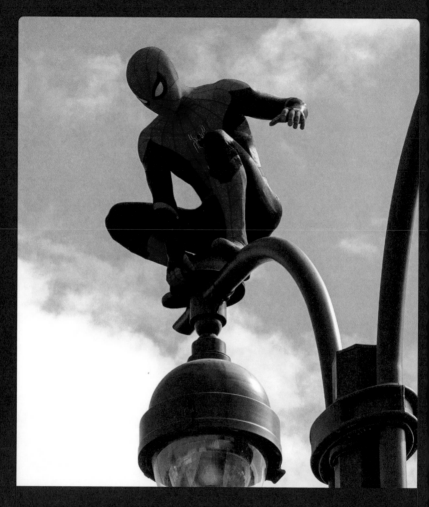

"Somebody's gotta look out
for the little guy, right?"
Peter Parker

START SMALL

The first step in taking on any challenge doesn't
have to involve blasting into outer space. It can be
as tiny as putting one foot in front of the other.
As simple as swinging from one skyscraper to the next.
Remember, heroes don't usually start their journeys by
saving the world, but by helping the ordinary people
around them. To make a start, look for the actions you
can take right now – no matter how small they seem.
You might be surprised to find out that it's the little
things that can make the biggest difference.

"We help people."
May Parker

LOOK FOR WAYS TO BE A HELPER

From supporting displaced people to lending
a sympathetic ear to anyone who needs one (even
the Green Goblin), helping is heroic. You don't need
superpowers or a thoughtful role model like Peter's
aunt, May. All it takes is kindness and the desire to
help someone in need. Donate your time or money,
genuinely ask what you can do, or simply make
someone smile. Compassion is all you need.
Well, maybe a spider bite too.
But mostly compassion.

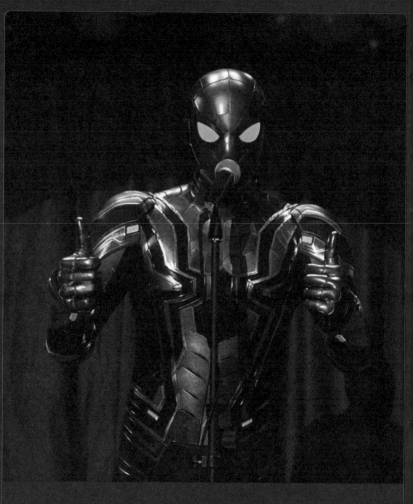

"She was really nice and bought me a churro."
Peter Parker

COUNT THE LITTLE VICTORIES

So you finally finished that project you've been working on. Or maybe you started that project. Either way, look at you go! Make sure to celebrate your wins. Whether it's snacking on a churro, buying that comic book you've been dreaming of, or just pulling off an epic secret handshake with your best friend, you deserve to commemorate every victory, big or small. The more you pay attention to your own accomplishments, the more motivated you'll be to keep going.

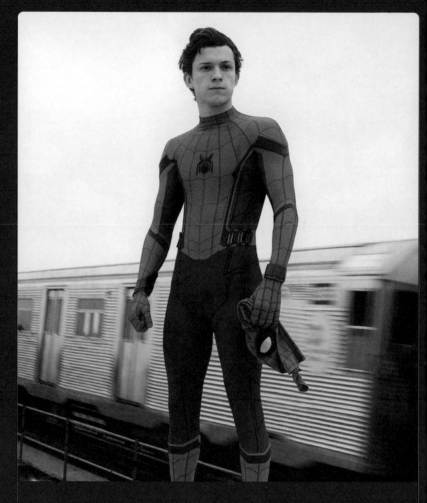

"With great power, there must also come great responsibility."

May Parker

ANSWER THE CALL

Sometimes, you're asked to clean the cobwebs off the ceiling. And other times, it's "Nick Fury" on the phone, asking for help with a global menace. Do not ghost the call to be a hero! If you have the power to help those who can't help themselves, how could you possibly refuse? Steel your nerves, hone your spider-sense, step up, and swing into action. The world (and The Multiverse) needs all the heroes it can get.

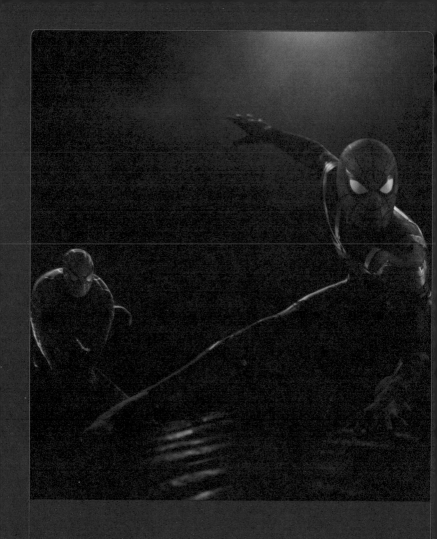

"It's what we do."
Peter Parker (Peter 2)

BE GOOD, DO GOOD

Perseverance. Self-sacrifice. A snarky quip or two.
It's all in a day's work when you're Peter Parker.
But the most important part of being good is doing
good. Picking up litter or helping nice old ladies might
not give you a lot of street cred, but making the world
a better place is more important than that. So forget
about looking cool – do good like no one's watching.
Save the planet, save a lost pet, save half the
population of the universe. And save some
time for a clever joke along the way.

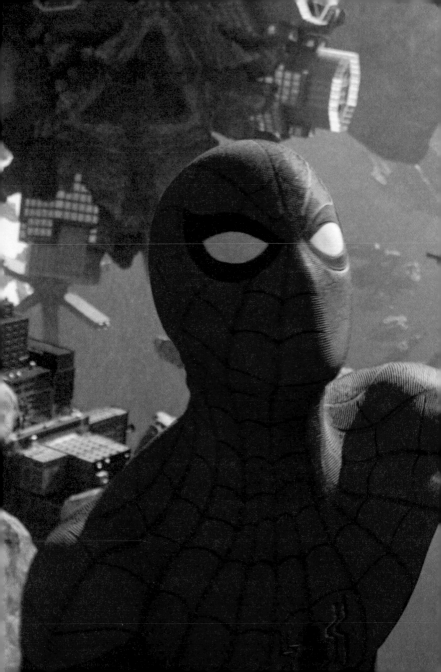

ALWAYS BE CURIOUS

Never lose your wonder about The Multiverse you live in. The world is amazing. It's spectacular. It's sensational. Make the most of your adventure by staying curious. You don't have to be in high school to learn and you don't need superpowers to try new things. Ask questions, dig deeper, and swing higher.

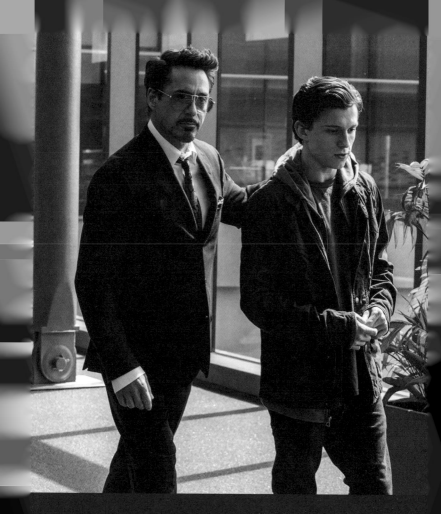

"Don't do anything I would do, and
definitely don't do anything I wouldn't do."

FIND A MENTOR

Everyone can do with a helping hand to show
them the webs, or ropes. Mentors listen, help you
meet interesting new people, and challenge you.
Occasionally, they give you a shiny suit with built-in
AI and nanotechnology. Of course, not everyone can
have a mentor like Tony Stark, but that shouldn't stop
you from trying. Aim to find an advisor with similar
passions to guide you. Get out there and get noticed,
and the right mentor might even come to you. Maybe
try catching a car in mid-air. Or the equivalent
of that in your own field. That works, too.

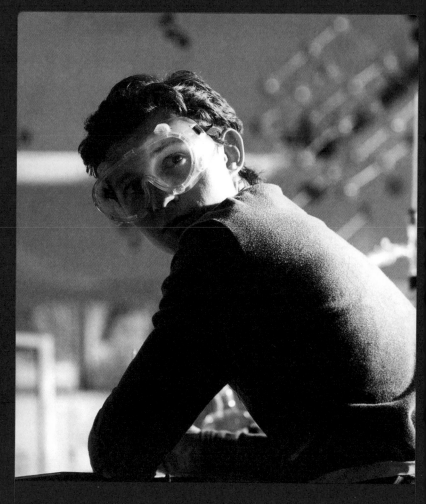

"I gotta figure out what this thing is and who makes it."

Peter Parker

DIG DEEPER

Whether you've had a falling out with an old friend or are trying to cure a bunch of Super Villains from being so villainous, a problem is a problem. You don't need superpowers to find a solution, although it would be nice. Ask questions and dig down to the smallest details to figure out the real cause. Peter Parker and his friends know how to break down one big problem (like a weird glowing thingy) into manageable steps. You can do the same. Observe, be creative, and don't be afraid to mess up. A lot. Like, really, a lot. It's just part of the process.

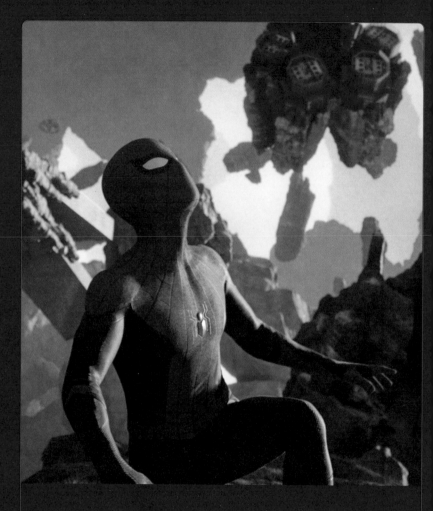

"You know what's cooler
than magic? Math."
Peter Parker

SEE THE WONDROUS IN THE MUNDANE

In a universe of Super Heroes, sorcerers, aliens, and monsters, sometimes it's hard to notice the everyday wonders. But take a look at your strengths. Maybe you're a geometry genius. Maybe the simplicity of your common sense makes you supreme. So call on your everyday skills to solve your problems – you don't always need a magic spell. And then, if you manage to avert a galactic crisis using your most mundane skills ... it's so much more magical.

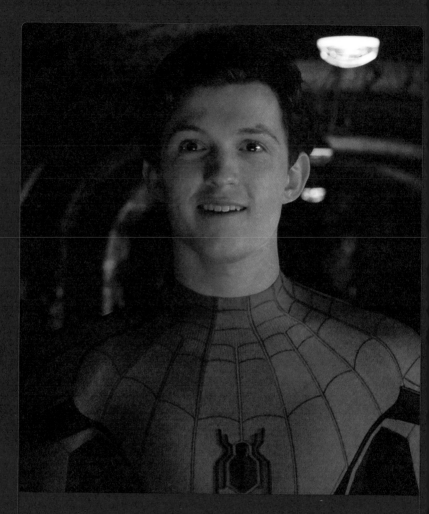

"I'm sorry, you're saying there's a Multiverse? Because I thought that was just theoretical. I mean, that completely changes how we understand the initial singularity."

Peter Parker

KEEP ASKING QUESTIONS

There's never a wrong time for a genuinely curious query. Amid an attempted robbery? Of course. Mid-punch from a super soldier with a metal arm? Why not? During the casting of a magic spell that might catastrophically alter The Multiverse? Well, okay, maybe wait for that one to finish first. But you never know what you might learn when you ask a question. Don't let anyone stamp out your inquisitive nature. Maybe the world would be a better place if we all talked more during a fight.

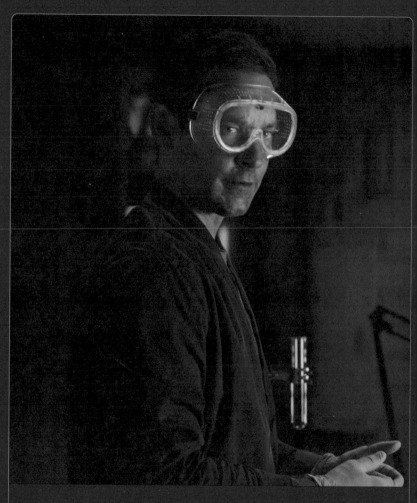

"We're curious as to how your web situation works, that's all."

Peter Parker

... ESPECIALLY THE WEIRD QUESTIONS

Don't feel shy about asking unusual questions. Creativity, new ideas, and a change of perspective can all come from thinking outside the box and posing the questions no one else asks. Plus, odd questions tend to get insightful and unexpected responses. But don't completely ignore your spider-sense – some queries are simply too personal, especially if you're quizzing someone from another universe, so proceed with caution!

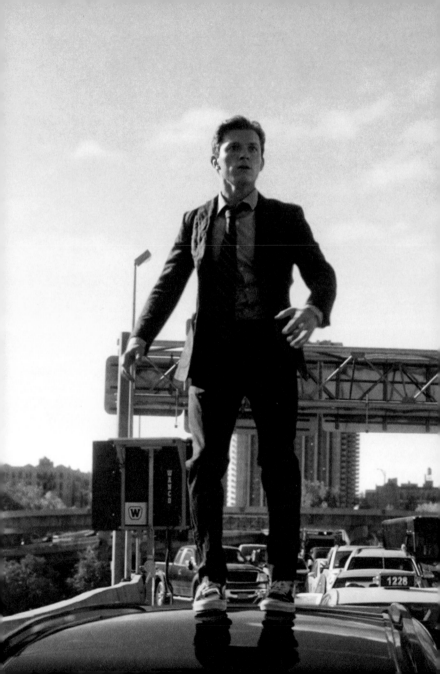

TRUST YOUR TINGLE

Do you have a nagging feeling that something isn't right? Does the situation seem a little bit off? Heed your intuition. Spider-Man has his spider-sense and you have your own sense of self. Trust it. An essential part of trusting your instincts is believing in yourself. You can't swing across the city rooftops if you're worried your web-shooters aren't up to scratch.

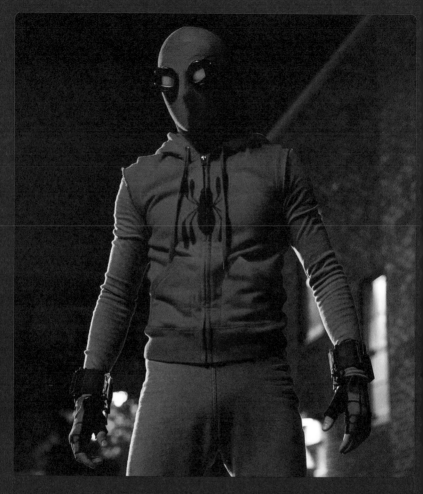

"Come on, Peter. Come on, Spider-Man."
Peter Parker

LIFT YOURSELF UP

Self-talk is an essential skill for any Super Hero,
and not just for narrating the latest video on your
channel. When you're slinging webs solo, you can't
rely on your fans to cheer you on – it's up to you and
you alone. Talk yourself through the hard times when
it feels like you've got the world on your shoulders,
or when you've literally had a building dropped
on your shoulders by a villain. Tell yourself
that you can do it enough times and
you'll believe it. You've got this.

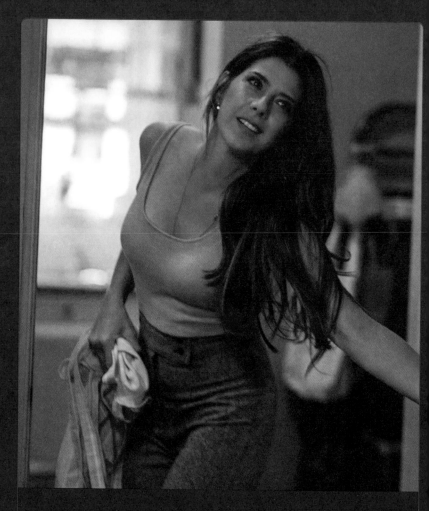

"Just trust your instincts
and you'll be fine."
May Parker

DON'T OVERTHINK IT

You have a plan. Great! But try not to make things extra complicated. For example, a six-step scheme that involves the Eiffel Tower is probably overdoing it. If experience has taught Peter Parker anything, it's that extravagant plans are the most likely to fall apart. If you try too hard to stick to what you think should happen, it could lead to anxiety, missed opportunities, and a ruined European holiday. Instead, trust your gut. You can handle whatever life throws at you. Unless it's four giant-sized Elemental Illusions. You might need some help with those.

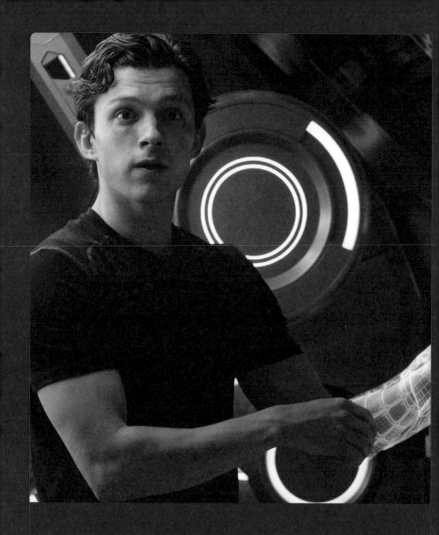

"I'm not Iron Man."
Peter Parker

DON'T TRY TO BE ANYONE ELSE BUT YOU

No two heroes are the same. Your mentor, your teammates, and even the version of you from another universe all save the day their way. Just be you! Play to your strengths, such as being quick thinking and good at clever jokes. Don't try to be that other hero – no matter how much the rest of the world wants you to. Honour those who have faith in you by working hard to be the best version of yourself. Or one of the best versions of yourself. You know, considering that whole Multiverse thing.

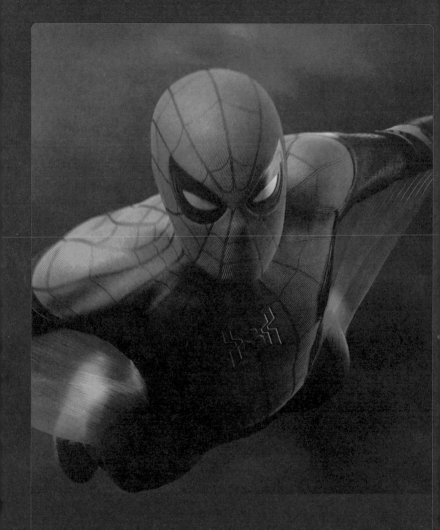

"You can't trick me any more."
Peter Parker

LISTEN TO YOUR HEART

Ever doubted that a friendship was genuine?
That your allies were not who you thought they were?
Take a good look at your relationships. Tap into your
intuition. Is it possible someone is putting on
appearances just to use you? If your heart tells you
you're being deceived, make the choice to stick up
for yourself. Walking away from a false friend takes a
special kind of bravery. It might hurt as much
as being pummelled by 500 high-tech drones,
but it's the only way to move forward.

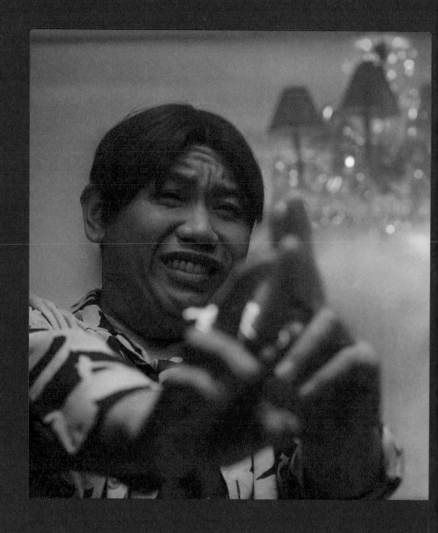

"Lola, you're right. I am magic."
Ned Leeds

BELIEVE IN YOUR OWN POWER

Some people find it easier than others to believe in themselves. When Ned Leeds discovers he can open mystic portals, he easily accepts the fact that he's extraordinary. Be like Ned and have faith in your gifts (and always listen to your Lola). You have superpowers! Yes, you. Whether it's your book smarts or street smarts, your creativity or ability to control space and time – it's your kind of magic. Confidence is a superpower in itself.

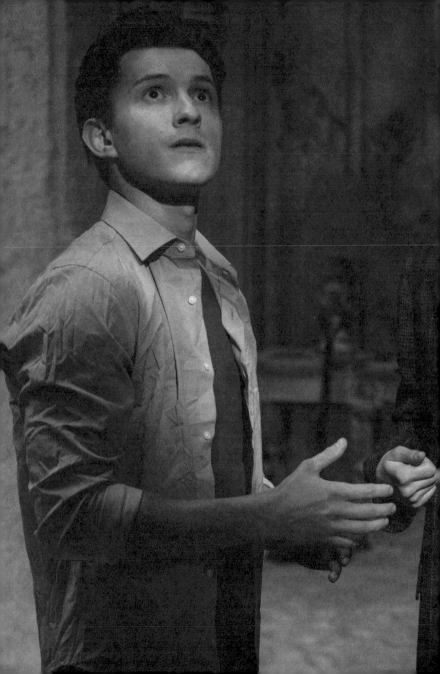

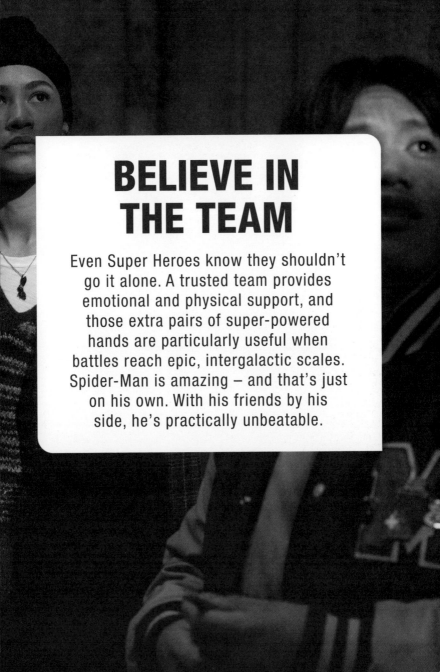

BELIEVE IN THE TEAM

Even Super Heroes know they shouldn't go it alone. A trusted team provides emotional and physical support, and those extra pairs of super-powered hands are particularly useful when battles reach epic, intergalactic scales. Spider-Man is amazing – and that's just on his own. With his friends by his side, he's practically unbeatable.

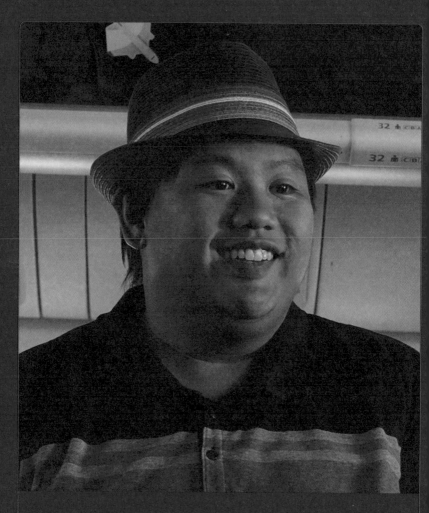

"You're an FOS now.
Friend of Spider-Man."
Ned Leeds

MAKE EVERYONE FEEL WELCOME

When a new member of the squad shows up,
remember – stay calm. You might have been on the
team first, and for longer, but it's not a competition.
Welcome your new friend with open arms. Not only
will you set a positive tone for your partnership,
but you'll also hit the ground running with teamwork.
Besides, it's a lot easier to run away from an army
of evil drones when you're not squabbling
with your teammates.

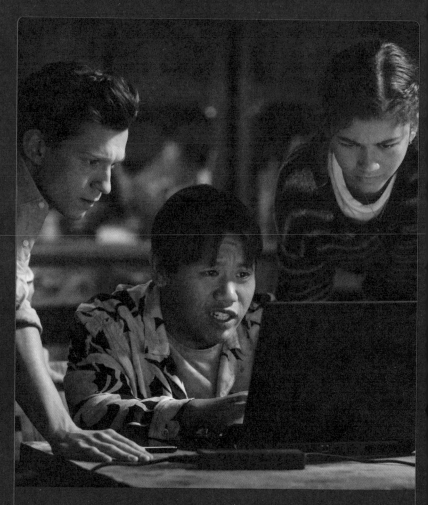

"We're gonna get through this. And we're gonna get through it together."
MJ

STAY STRONGER TOGETHER

Family. School. Work. Angry villains. Whatever
you're facing, having a true friend at your side
can be the difference between saving The Multiverse
and almost saving The Multiverse. True friends like
MJ and Ned are hard to find, but they are so worth it.
They will support you as you learn and experiment
and hold you when you cry. So how do you get one
of these true friends? Make an effort to get to know
people. Reintroduce yourself if you have to.
And don't be afraid to show them who you
really are without your mask on.

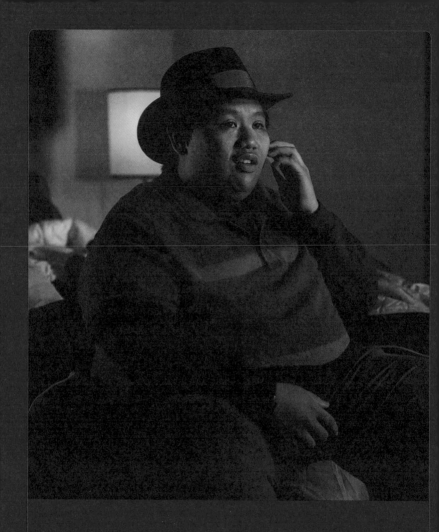

"Guy in the chair!"
Ned Leeds

FIND THE ROLE THAT'S RIGHT FOR YOU

No powers? No problem. There's a place for you on the squad. Your name doesn't have to be on a comic book for you to be a hero. You can play a vital role in any team by utilizing your real-life superstrength. Be the organizer; the voice of reason; or even the guy that sits in a chair, wearing a headset, telling the other guys where to go. Every team needs someone they can rely on to help them out of a jam — whether that's planning a last-minute event or escaping a burning building.

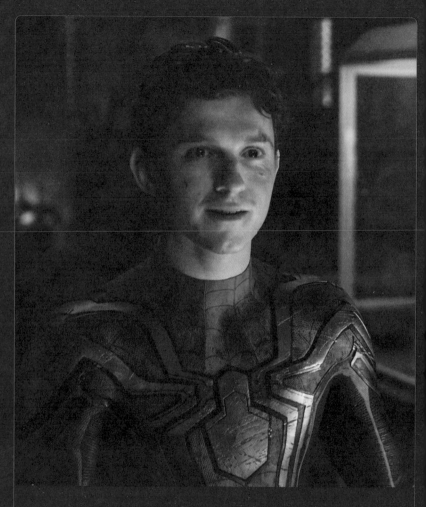

"I couldn't do any of this without
you, so thank you."
Peter Parker

APPRECIATE EVERYONE'S CONTRIBUTIONS

To be a team player like Spider-Man, acknowledge
the efforts of your squad members. But remember,
sharing your appreciation is one of those rare times
to cool it with the quips! Sincere gratitude goes
further than one of Doc Ock's mechanical arms.
Be genuine and specific with your praise, and you'll
make each teammate feel like they could take on
Thanos. The same goes for friends and family.
Thank them genuinely, and your kind words
will stick to them better than webbing.

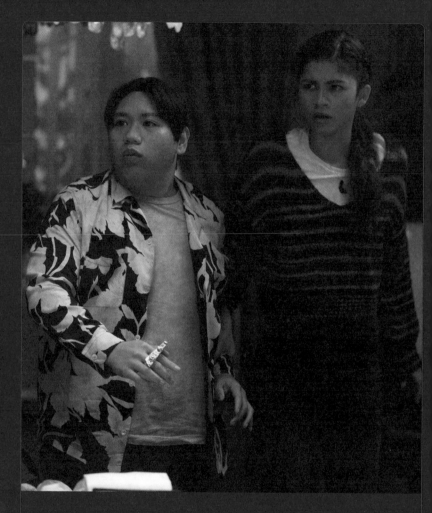

"You're a deeply mistrustful person and I respect it."
Peter Parker (Peter 3)

EMBRACE THEIR QUIRKS

Everyone has their quirks. Maybe they wear
a fedora to parties. Maybe they throw bread rolls
at Spider-Mans they don't know. Accept and respect
your teammates' personalities, no matter how
unusual. When your colleagues feel like they have the
freedom to express themselves and their ideas, they
can do some of their best work. And the same goes
for you. Show off that collection of retro computers
you dug out of a skip. You never know who
might stop by to admire it – and then offer
you an internship at Stark Industries.

LEARN FROM MISTAKES

We all mess up. Even Spider-Man. Especially Spider-Man. Real heroes don't try to hide their imperfections behind illusions. Instead, they ask themselves, "What am I going to do about it?" Admitting your mistake is the first step to cleaning up your mess. Then it's time to swing into action.

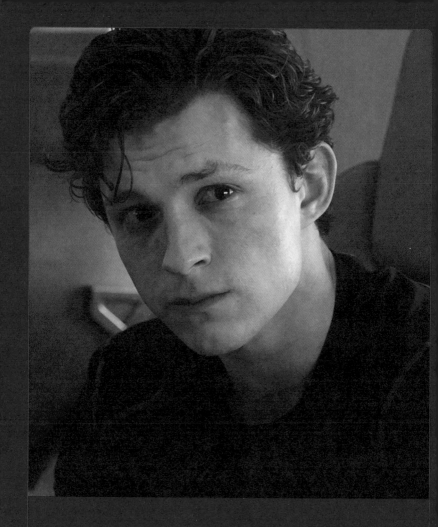

"Now, your friends are in trouble, you're all alone, your tech is missing. What are you gonna do about it?"

Happy Hogan

FIX WHAT YOU CAN

You must be looking rough if Happy Hogan feels the need to give you a pep talk. But Happy offers some timeless advice. Take a moment to think about how you're going to make things right. It might mean making a heartfelt apology or accepting the consequences without complaint. (But if someone tricks you into giving away a gift from Tony Stark, it's understandable to complain a little.) You might not be able to fix everything – like, say, London's Tower Bridge after hundreds of drones are unleashed upon it – but what's most important is that you're sincere in your efforts.

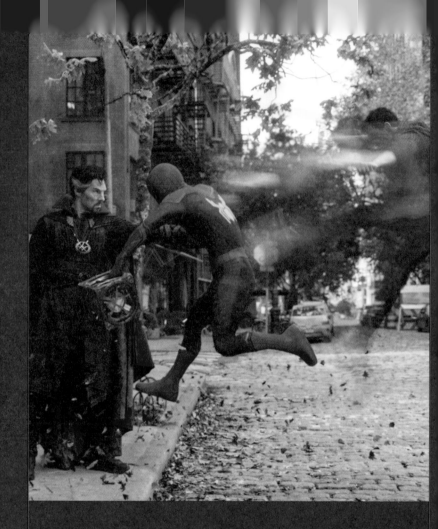

"I know that this is my mess and I swear to you that I'll fix it, but I'm gonna need some help."

YOU DON'T HAVE TO GO IT ALONE

If your best friend drops the ball on that thing you've been working on together, you don't expect them to fix things all by themselves, right? The same goes for your messes, no matter how big they are. Even if they're destroying-the-fabric-of-reality big. Don't feel like you're on your own. Reach out to friends and family. They'd jump through magic portals if they could to be there when you need them the most. With their help, you'll find what you need to get everything in the right place again.

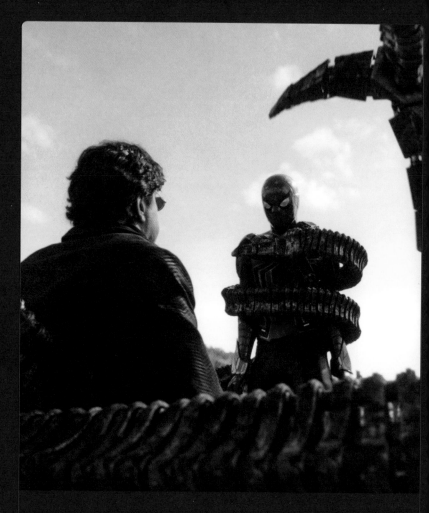

"My Aunt May taught me that everyone deserves a second chance."

Peter Parker

FORGIVE OTHERS, AND YOURSELF

Forgiveness isn't easy. Constructing a handheld supercollider to transform a sand-man back into a man-man will seem simple compared to forgiving those who've wronged you. But bad guys can be good guys again. Enemies can become friends. They just need the opportunity to see that they can change. Give yourself a second chance too, by forgiving your own missteps. Acknowledge your mistakes and decide what to learn from them. Then let go – and ace the Super Hero landing.

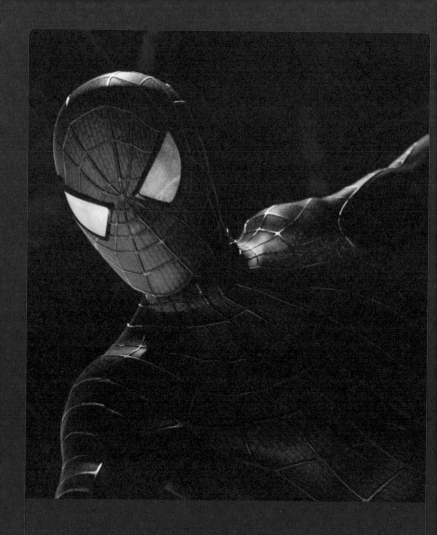

"Trying to do better."
Peter Parker (Peter 2)

KEEP MOVING FORWARD

Spider-Man never stops working to be a better
hero. And it goes beyond running experiments on
his web fluid in the lab. The web-slinger often
stumbles: he disappoints his friends, misses the next
skyscraper, gets knocked out of the air by Thanos's
warship. But Spider-Man always gets back up, usually
with a joke at the ready. He gets back up with a
promise to himself to do better. You can do the same.
Hold your head high, strike that power pose,
and keep pushing, even if your battles seem
small and don't involve Infinity Stones.

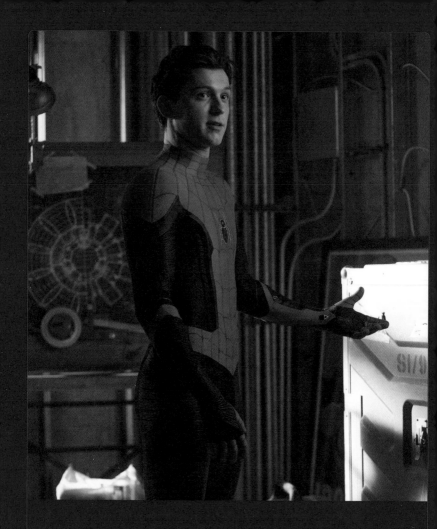

"You could have just left us to die. Why didn't you?"
"Because that's not who he is."
Doc Ock and MJ

DON'T GIVE UP

As much as you might wish you could just push a magic button to make all your problems go away, you know that being a true hero is never that easy. Don't call it a day just yet. Don't hang up the web-shooters until you've done everything you can to help those who need you. Stay strong and stick to your convictions. You know in your heart what the right thing to do is. Fight for everyone – the baddies too – and don't let up, even if it means making a sorcerer mad at you. They'll forgive and forget.

Senior Designer Clive Savage
Senior Production Editor Jennifer Murray
Senior Production Controller Mary Slater
Managing Editor Emma Grange
Managing Art Editor Vicky Short
Publishing Director Mark Searle

Designed for DK by Ray Bryant
Cover by Mark Penfound

DK would like to thank: Kristy Amornkul, Capri Ciulla, Hayley Gazdik, Nikki Montes, Jacqueline Ryan-Rudolph, Keilah Jordan, and Ariel Shasteen at Marvel Studios; John Morgan III; Chelsea Alon at Disney Publishing; Kelly Knox for her text; Shari Last and Alastair Dougall for editorial help; and Kayla Dugger and Julia March for proofreading.

First published in Great Britain in 2023 by
Dorling Kindersley Limited
One Embassy Gardens, 8 Viaduct Gardens,
London SW11 7BW
A Penguin Random House Company

10 9 8 7 6 5 4 3 2 1
001–331580–Apr/2023

The authorised representative in the EEA is Dorling Kindersley Verlag GmbH. Arnulfstr. 124, 80636 Munich, Germany.

A CIP catalogue record for this book is available from the British Library.
ISBN 978-0-2415-6812-5

Printed and bound in China

For the curious

www.dk.com

MIX
Paper | Supporting
responsible forestry
FSC™ C018179
www.fsc.org

This book was made with Forest Stewardship Council™ certified paper – one small step in DK's commitment to a sustainable futu
For more information go to
www.dk.com/our-green-pledge

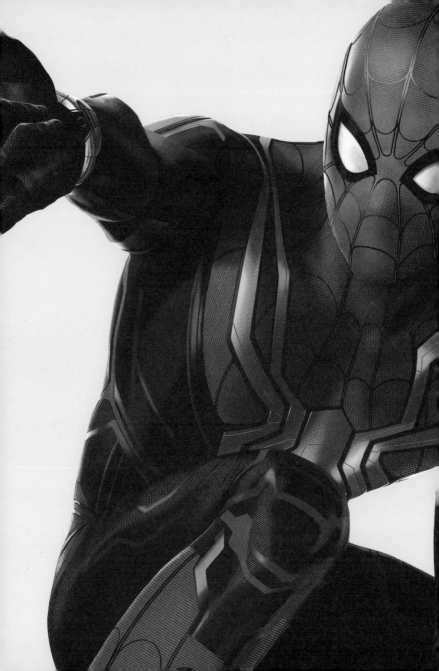